D1015629

Prince.

AND OTHER DOGS
1850–1940

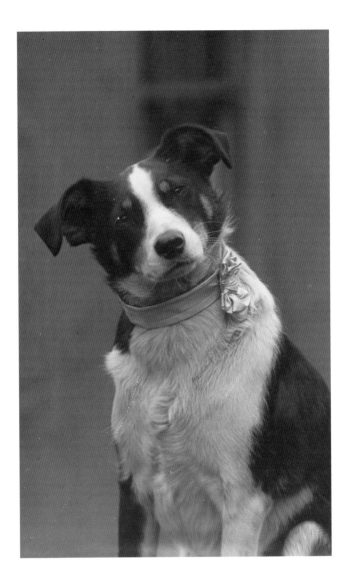

Prince.

AND OTHER DOGS
1850–1940

LIBBY HALL

BLOOMSBURY

For information address
Bloomsbury USA, 175 Fifth Avenue,
New York, N.Y. 10010.

Published by Bloomsbury USA, New York and London
Distributed to the trade by St. Martin's Press

Library of Congress Cataloguing-in-Publication Data
has been applied for

ISBN 1-58234-097-8

First US Edition

10 9 8 7 6 5 4 3 2 1

Printed in Italy by Artegrafica S.p.A., Verona

Prince.

AND OTHER DOGS
1850–1940

The one hundred and twenty-seven photographs in this book, dating from the 1850s to the 1940s, come from a collection of over a thousand. The collecting began by chance in the early 1960s. I had always been interested in photography and was working as a press photographer, when I discovered that a local junk shop doing house clearances was simply throwing away old photographs. I persuaded them to let me have those photographs, really just in order to save them from the dustbin. Then, perhaps because I have lived with dogs all my life – and couldn't imagine life without them – I began to be intrigued by the photographs that had dogs in them.

As the collection grew, it seemed to turn into a testimony to the extraordinary relationship that can exist between dogs and people: dogs that you knew were loved companions of people living on their own, dogs that were included in photographs as important members of a family or group. By then old photographs had become 'collectable' and I no longer had to worry about them being thrown away. But nevertheless I went on searching for images of dogs, becoming more and more fascinated and touched by the photographs I found. When had they been taken and where? What exactly was happening? What happened next? In some cases there were dates and names

but mostly not. So I learned more about the various formats of the photographs: cartes de visite, stereos, cabinet prints…but this only gave me approximate dates, and in the end dates didn't matter, the dogs were the same dogs whether in 1850 or 1920.

Some of the pictures are hilarious (how often it really is true that dogs look like their owners!) and some I find incredibly moving. These are the ones, taken in areas like the East End of London, where the price of the photograph would have represented a substantial part of the owner's weekly income. Often these dogs are grey in the muzzle and you imagine that time to capture their likeness was running out. Sometimes these dogs are on their own, sometimes the owner sits with them, but you know the main reason for the photograph is not the person but the dog.

In other more affluent photographs perhaps the dog was included because it was the fashionable thing to do (the Royal Family were often photographed with their dogs of course – so were actors and Gaiety Girls).

But, rich or poor, funny or sad, for me these frozen moments capture, not only the passion we can have for dogs, but also the fleeting transience of life: dogs' lives are poignantly short – so too are people's.

This book is dedicated to the people and dogs in these photographs.

LIBBY HALL

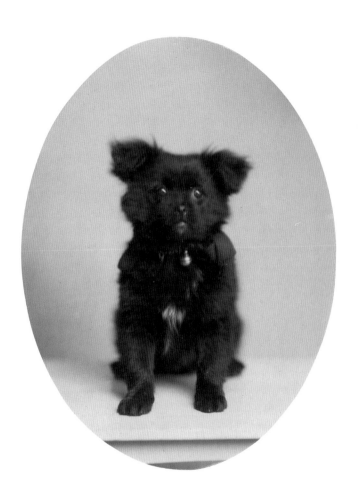

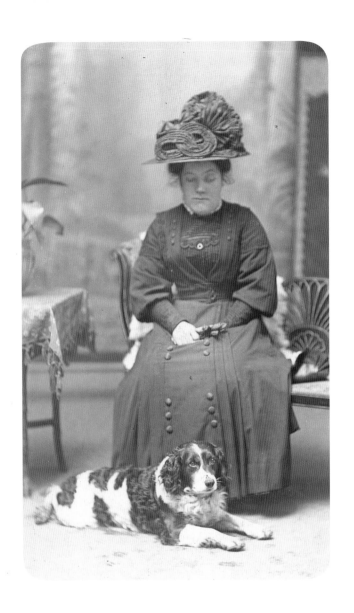

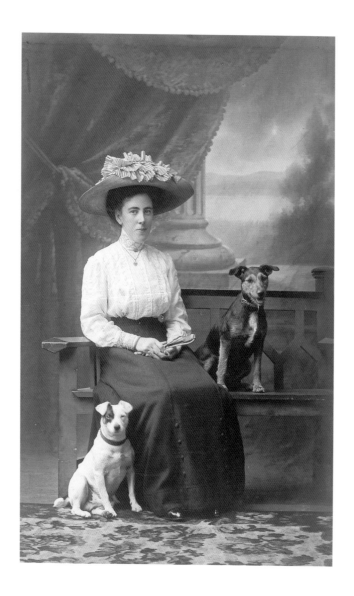

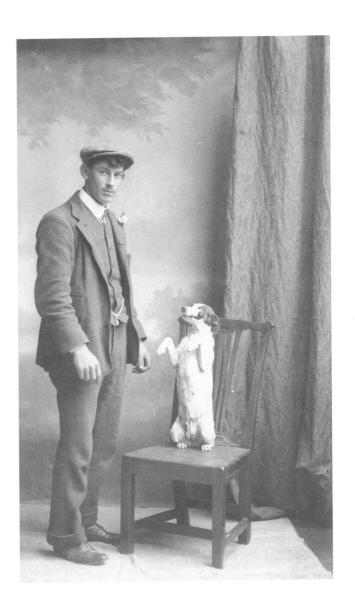

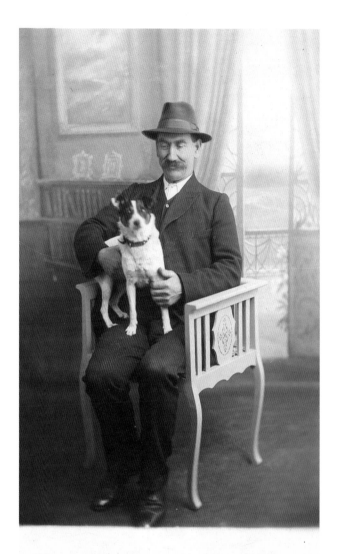

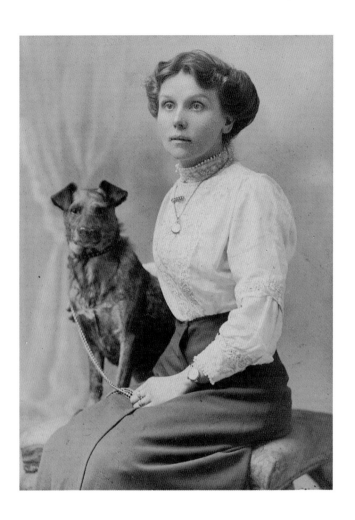

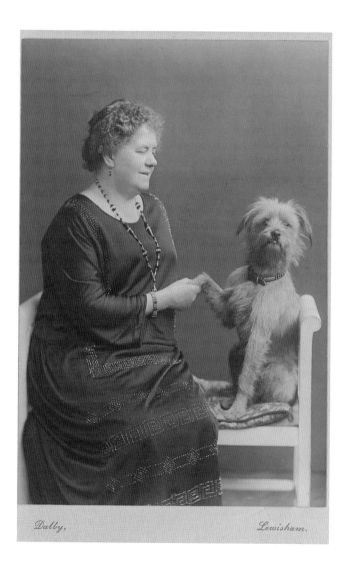

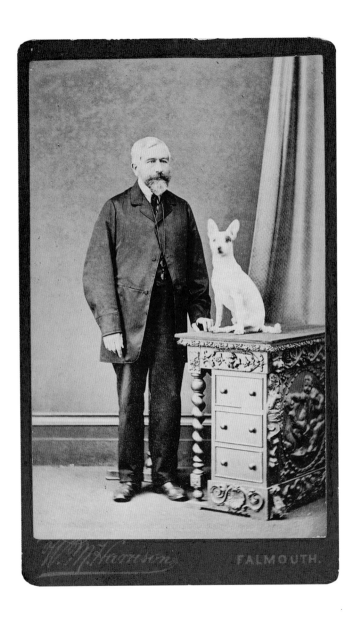

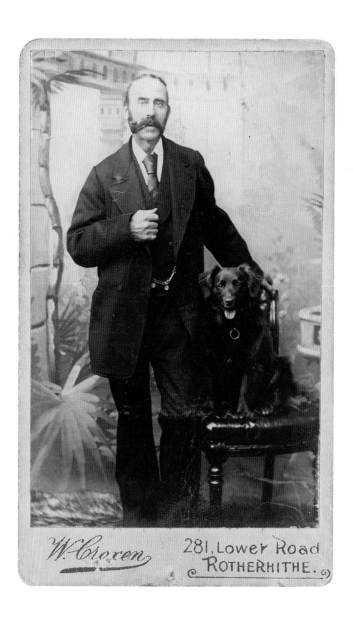

W. Croxen 281, Lower Road
ROTHERHITHE.

11

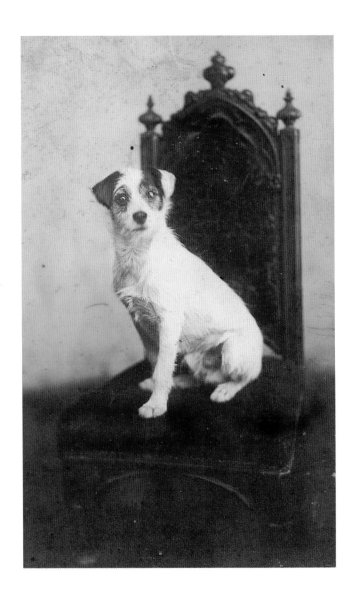

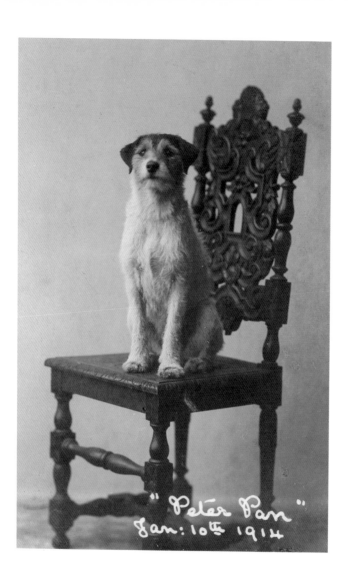

"Peter Pan"
Jan: 10th 1914

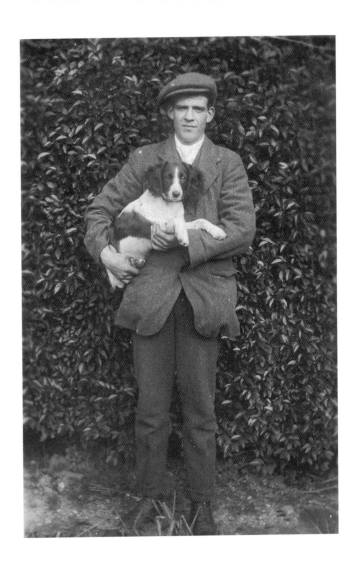

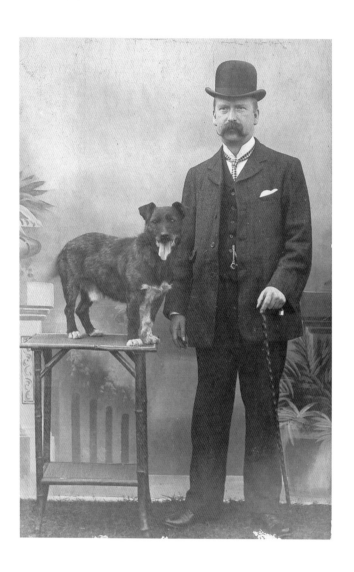

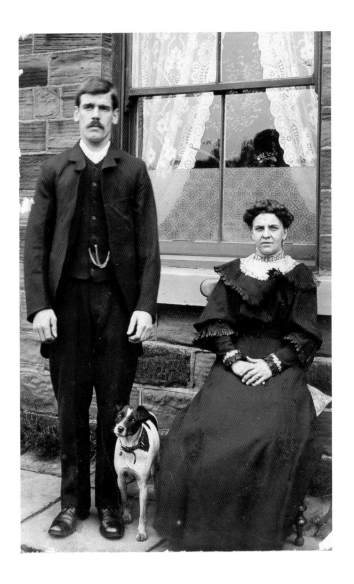

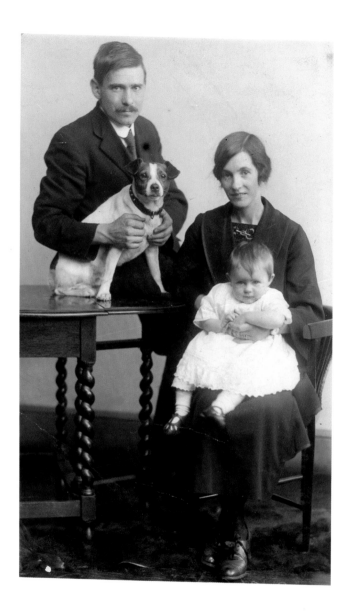

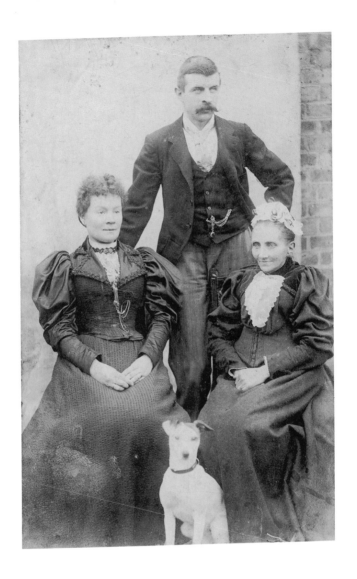

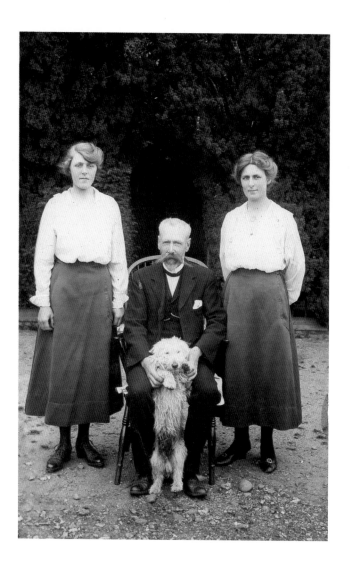

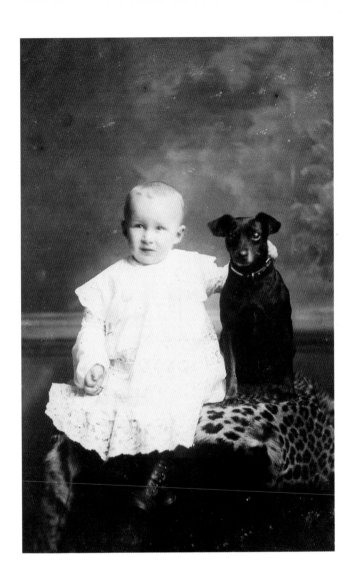

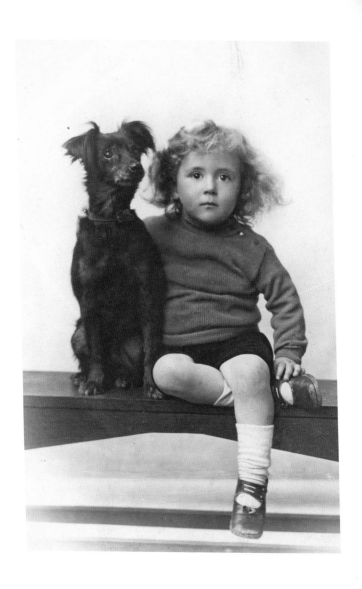

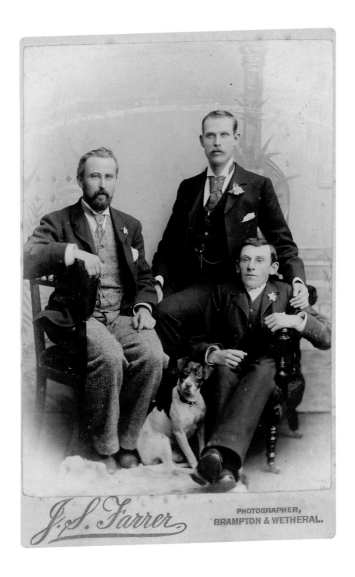

J. S. Farrer

22

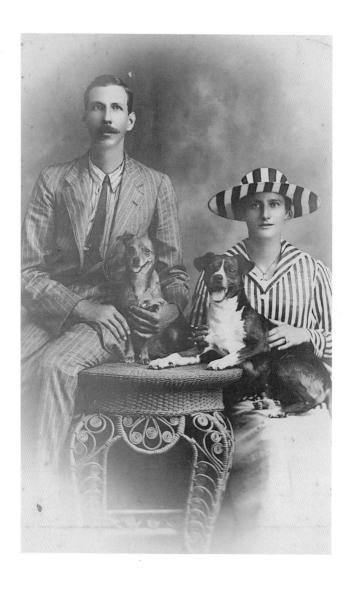

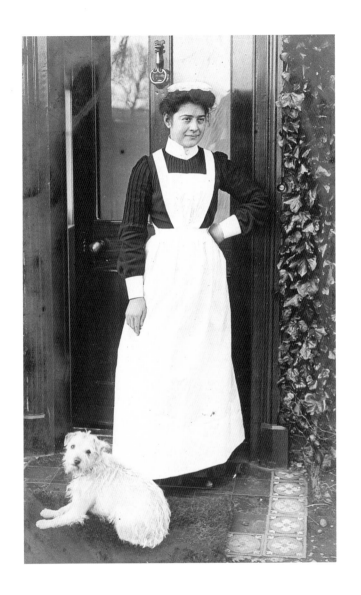

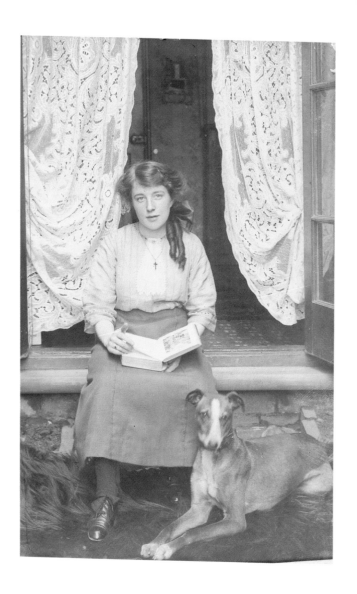

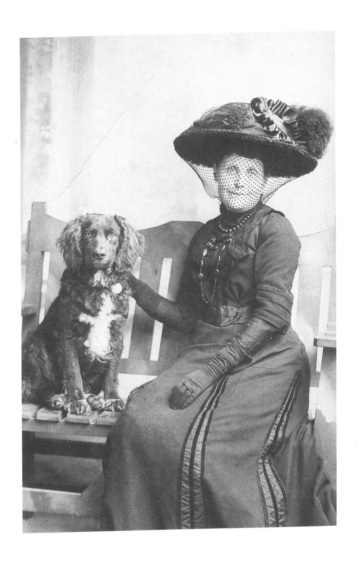

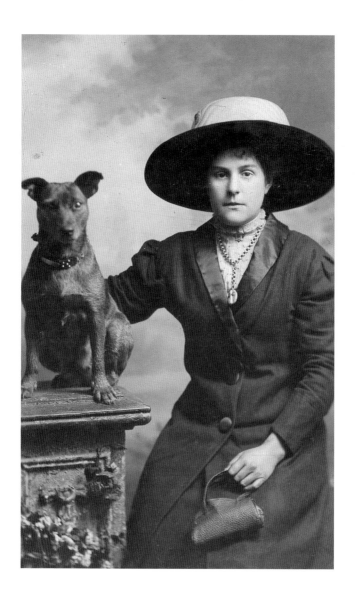

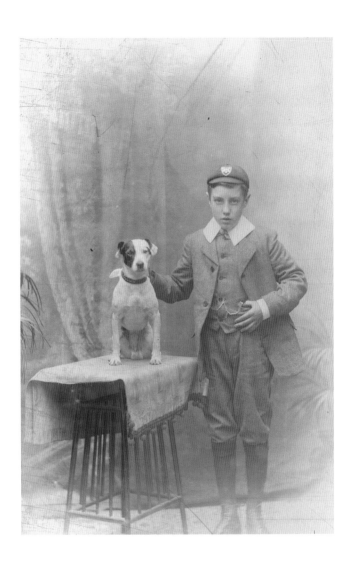

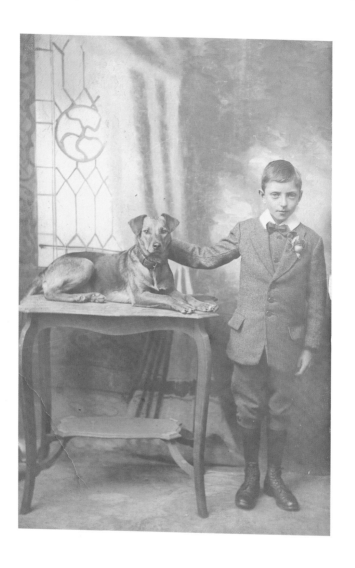

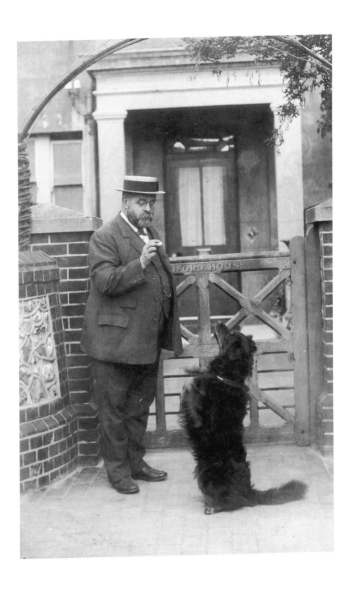

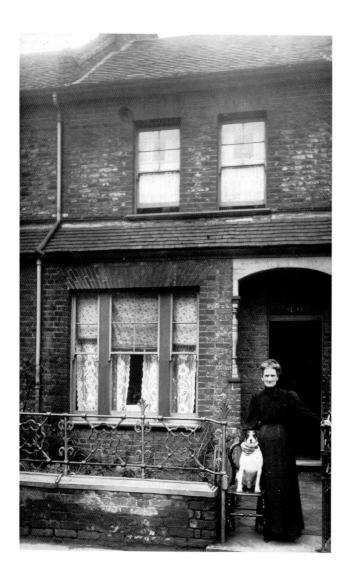

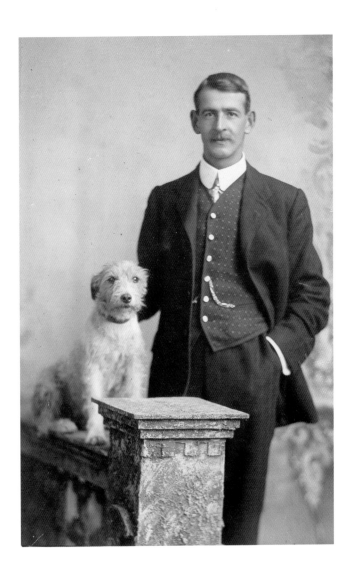

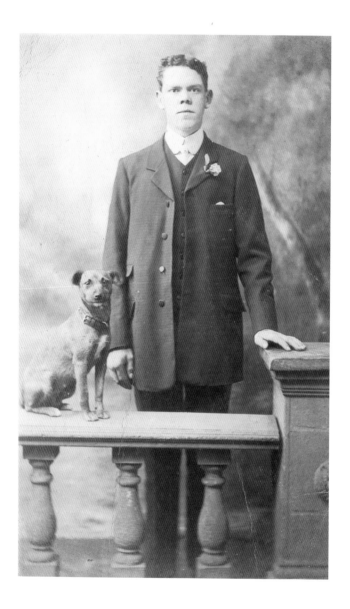

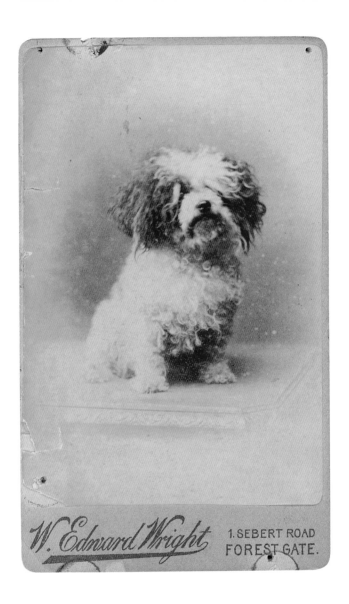

W. Edward Wright 1. SEBERT ROAD
FOREST GATE.

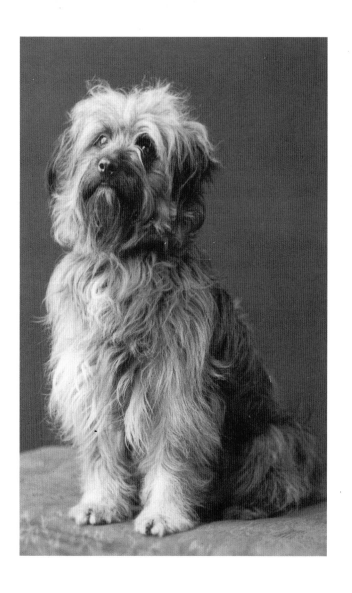

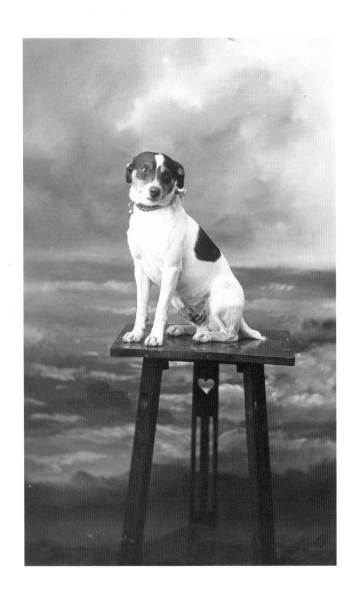

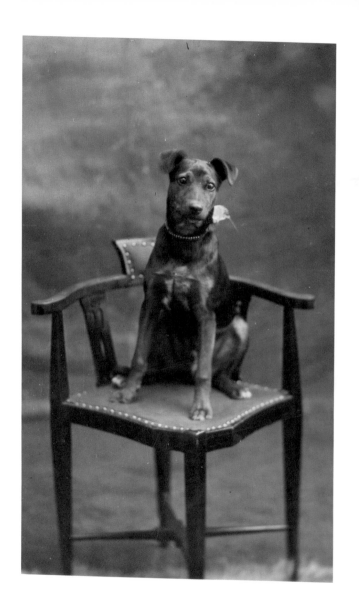

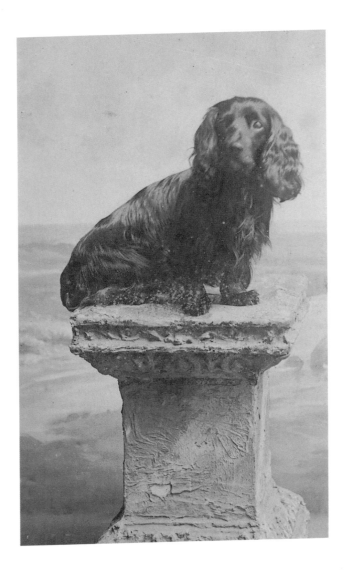

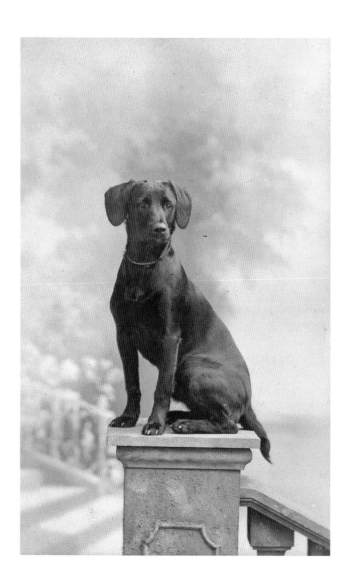

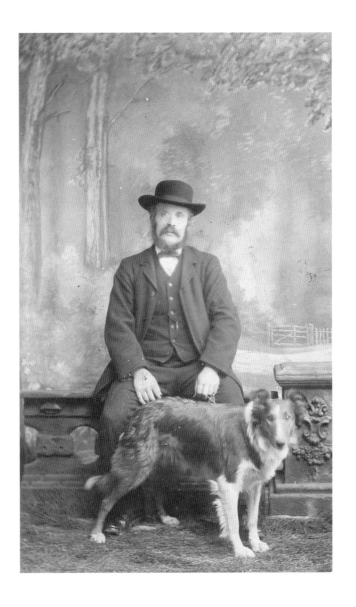

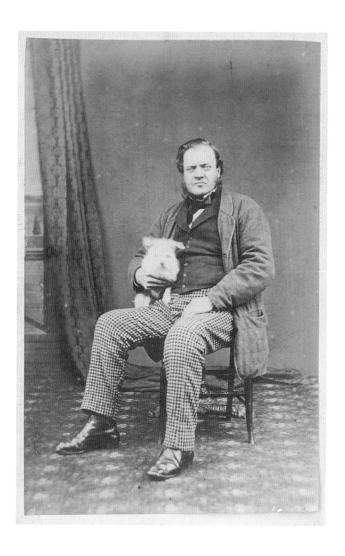

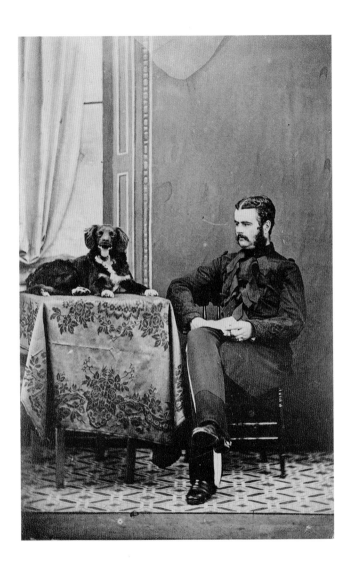

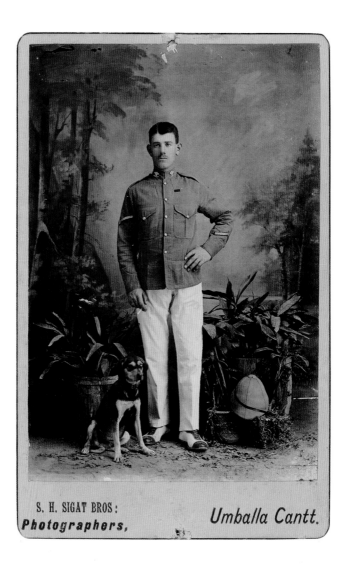

S. H. SIGAT BROS:
Photographers,

Umballa Cantt.

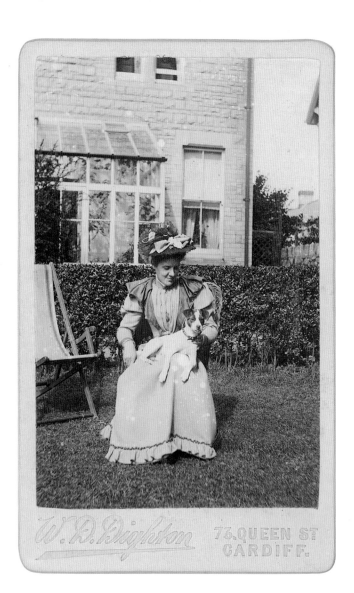

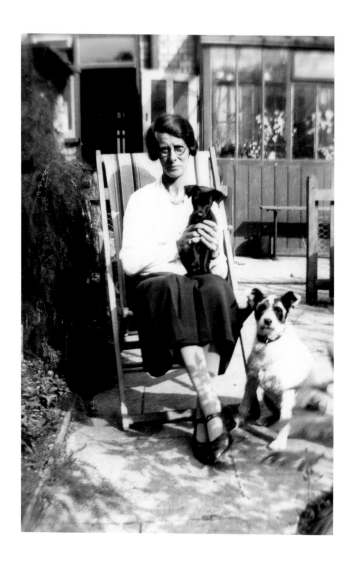

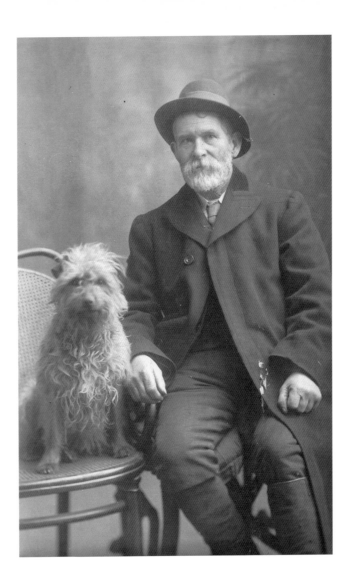

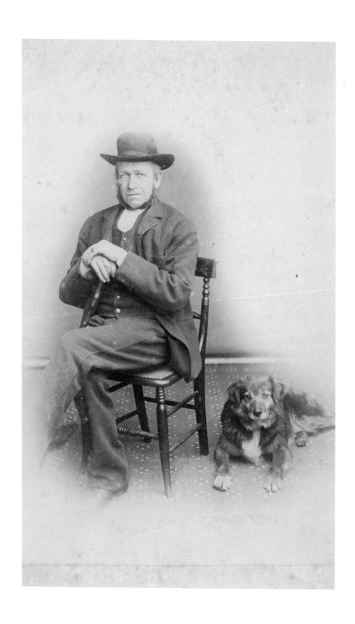

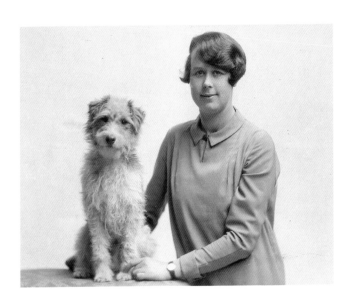

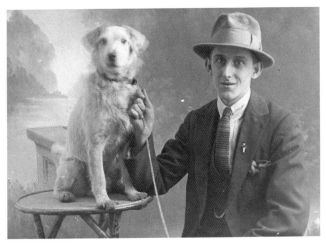

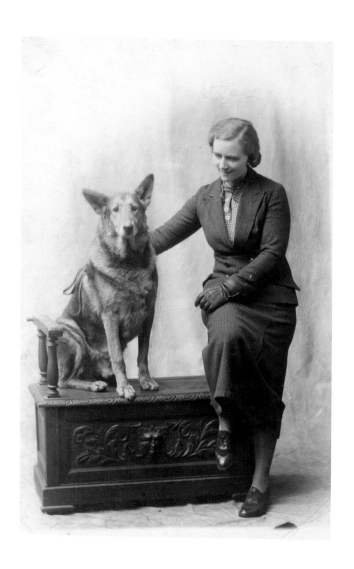

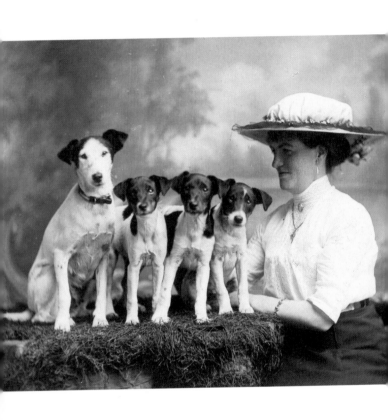

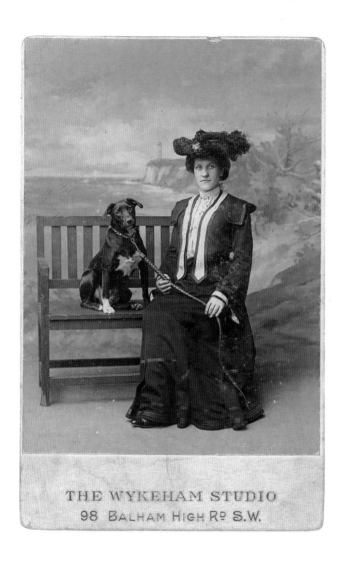

THE WYKEHAM STUDIO
98 BALHAM HIGH RD S.W.

51

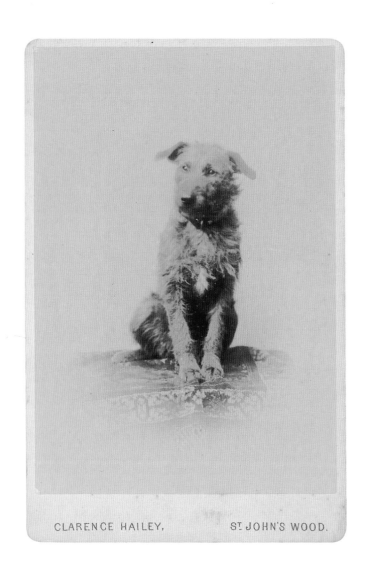

CLARENCE HAILEY, St JOHN'S WOOD.

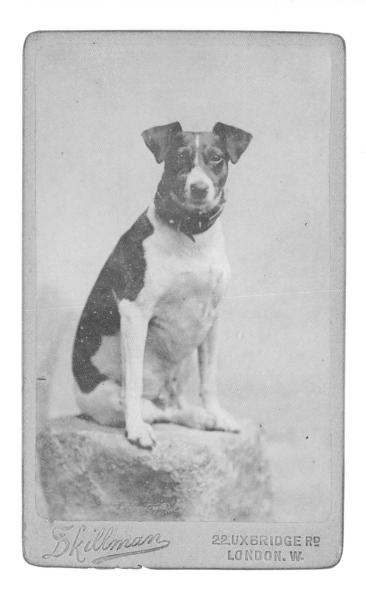

Skillman

22, UXBRIDGE R⁰
LONDON. W.

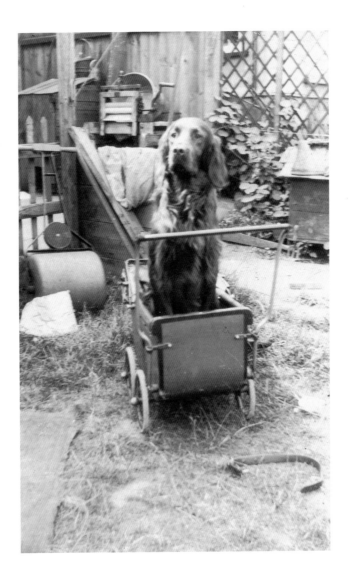

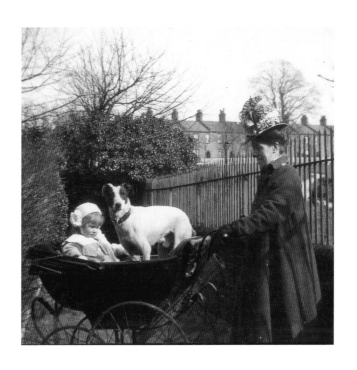

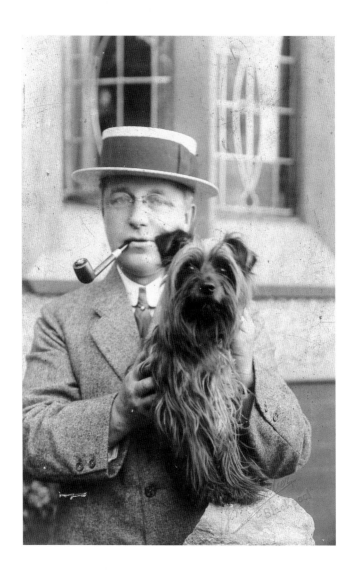

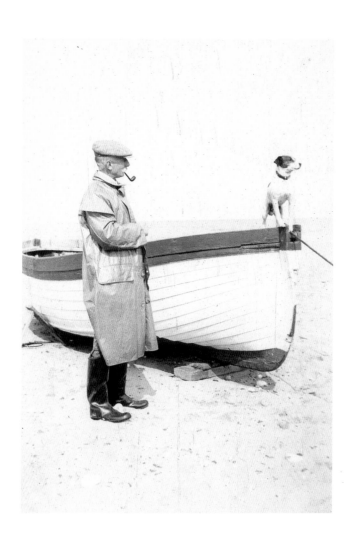

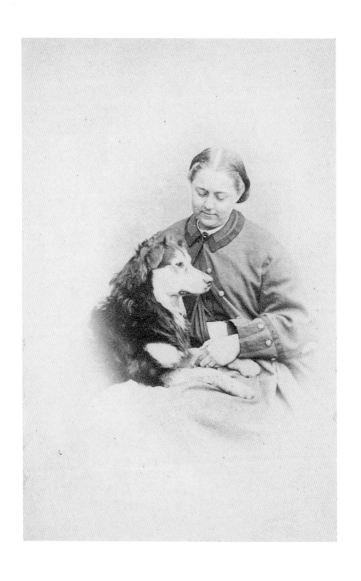

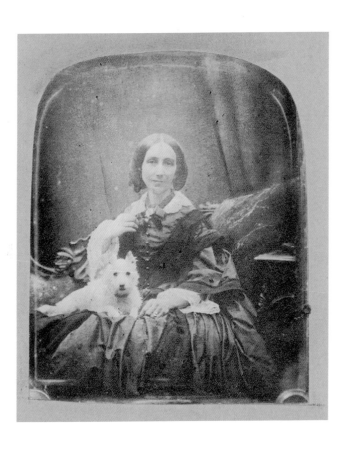

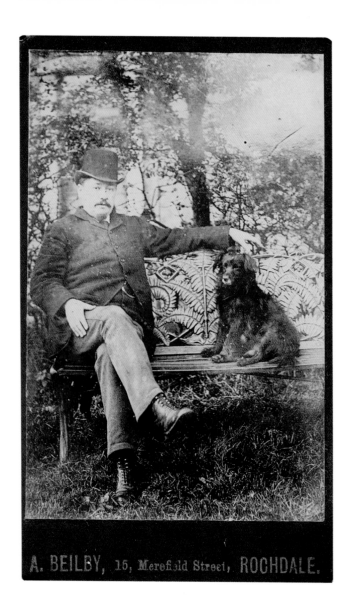

A. BEILBY, 15, Merefield Street, ROCHDALE.

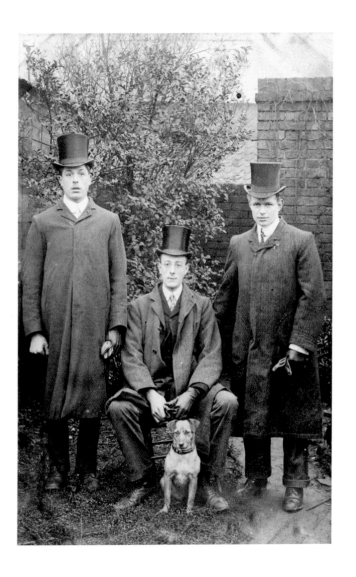

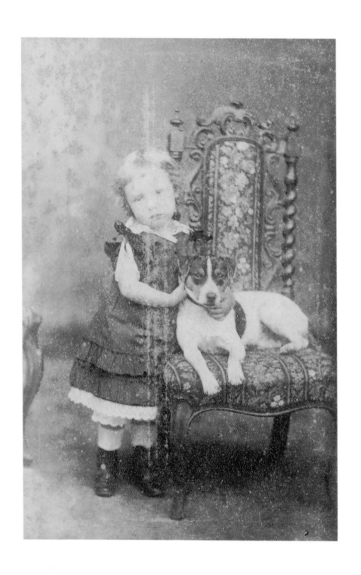

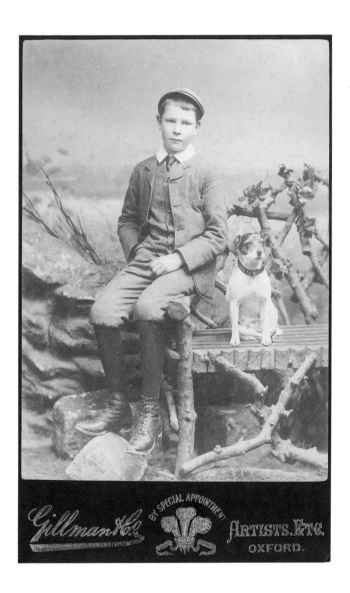

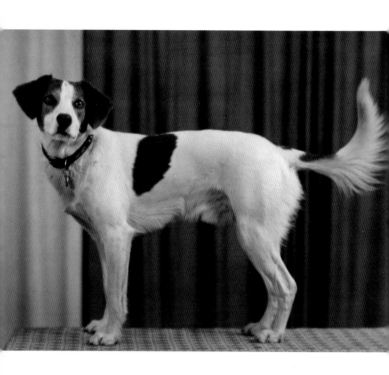

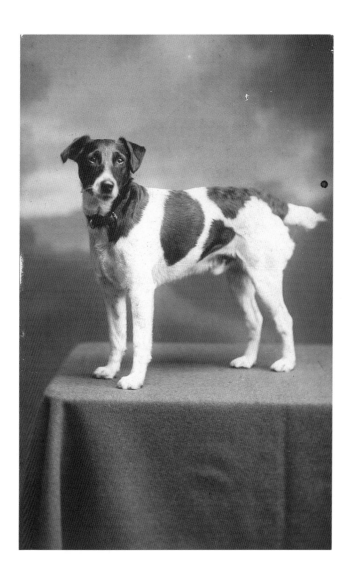

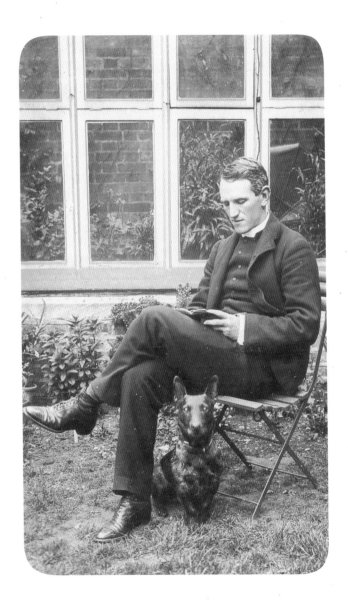

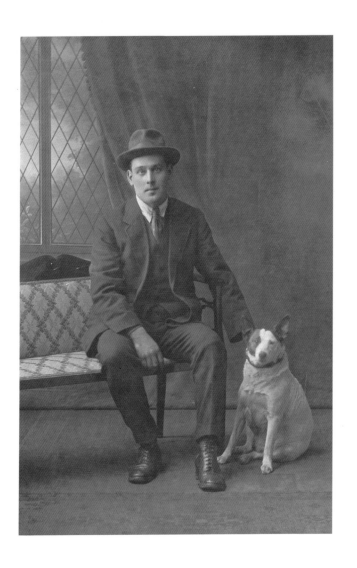

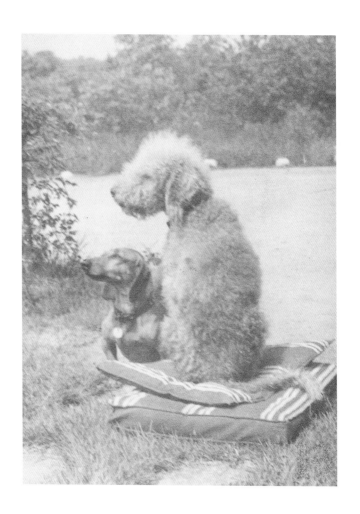

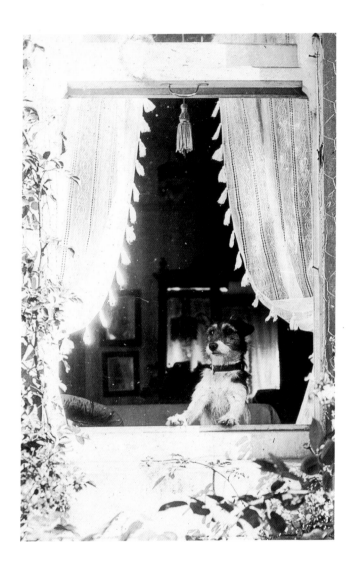

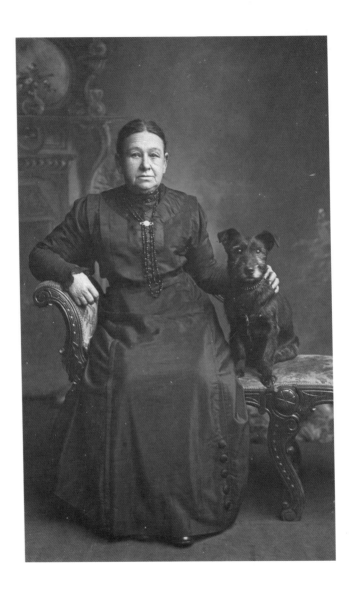

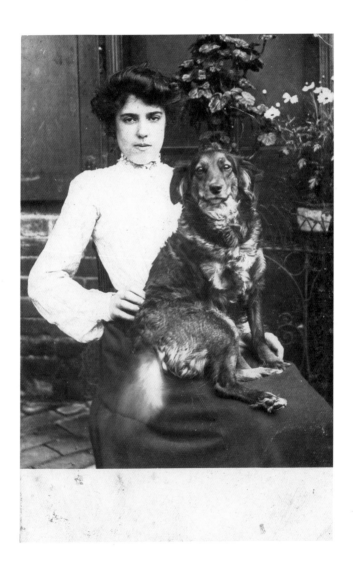

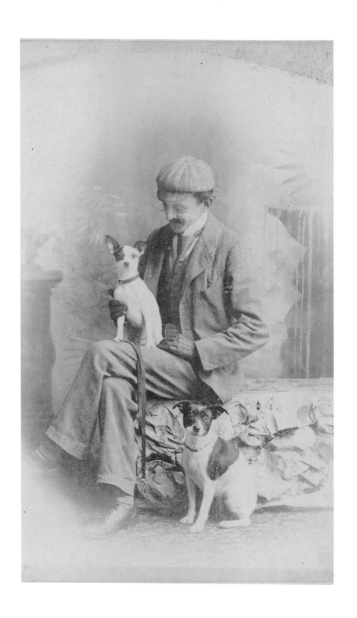

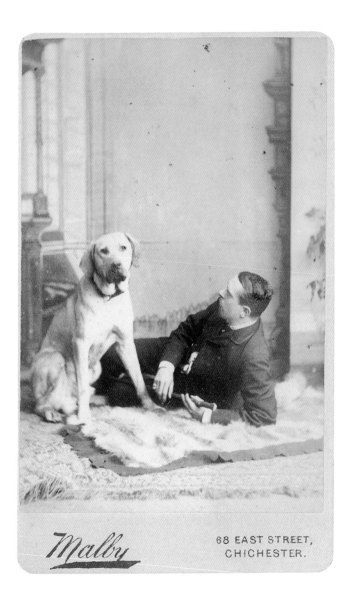

68 EAST STREET,
CHICHESTER.

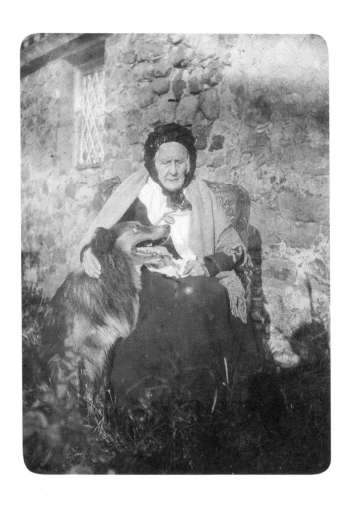

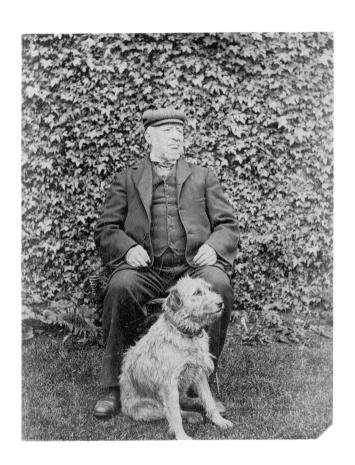

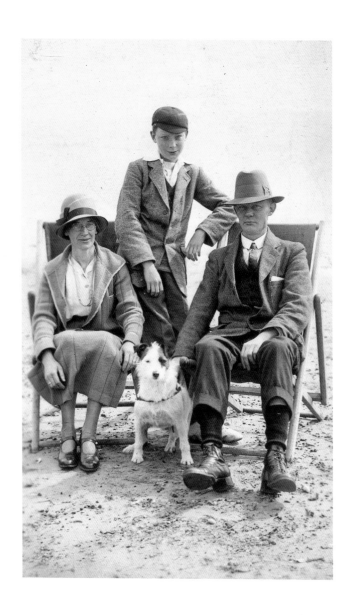

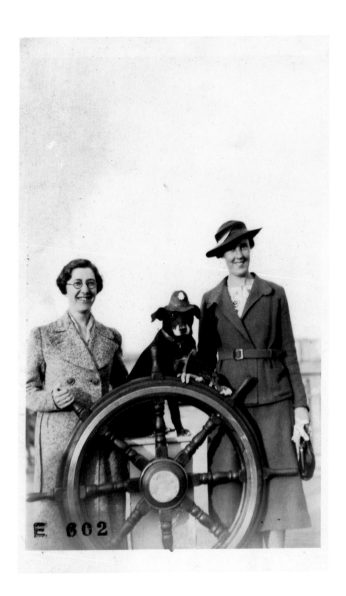

E 602

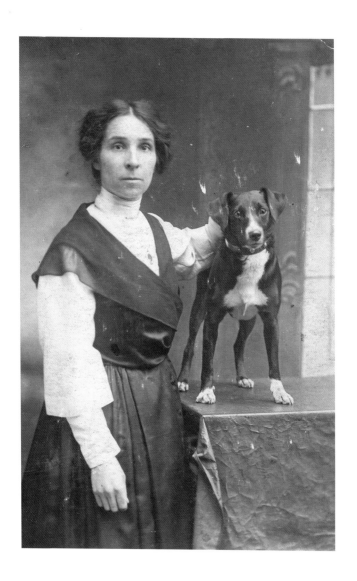

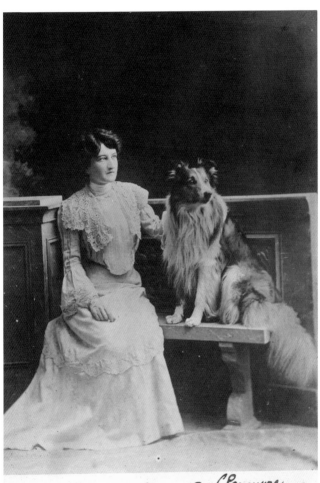

'Bobs'. Pa. (Panmure
Perfection)
(Gordon)
"On the alert" On Guard" 8·9·03

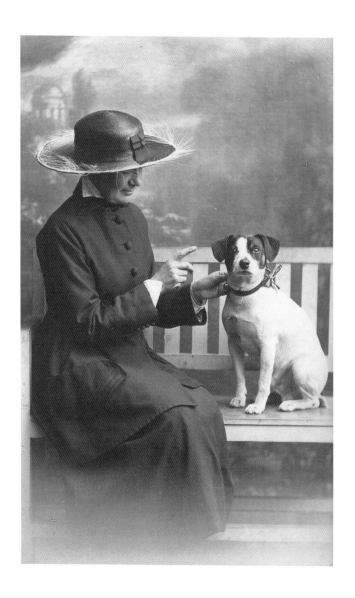

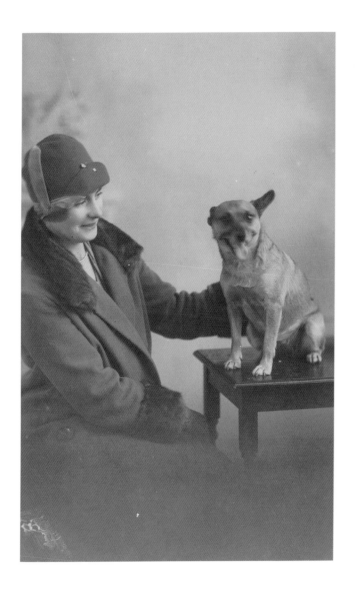

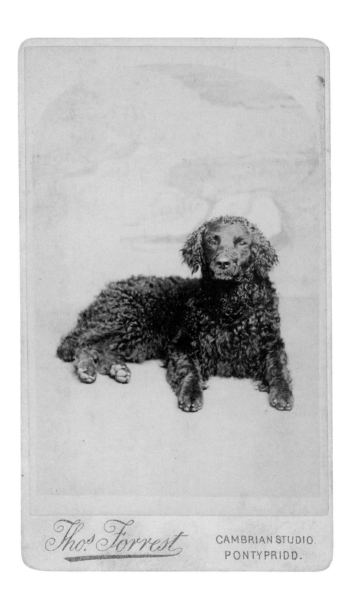

Thos. Forrest

CAMBRIAN STUDIO.
PONTYPRIDD.

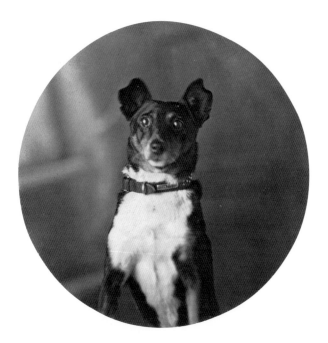

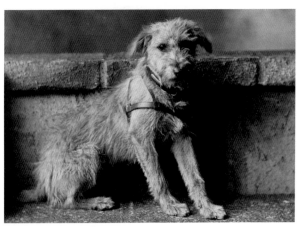

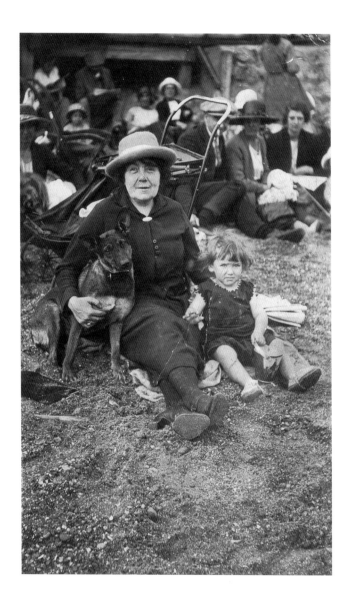

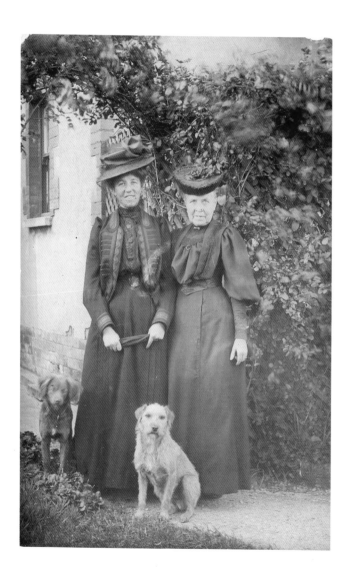

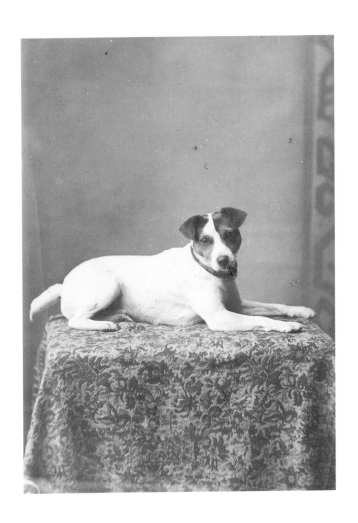

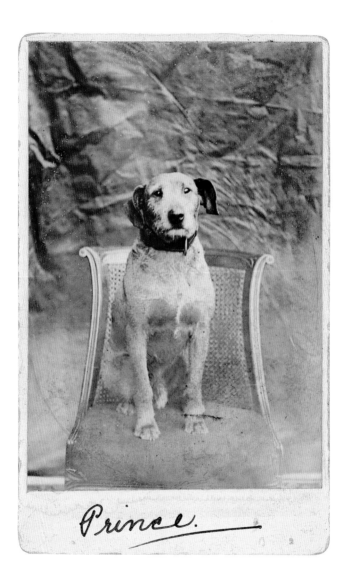

Prince.

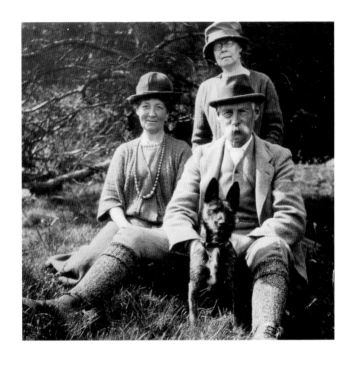

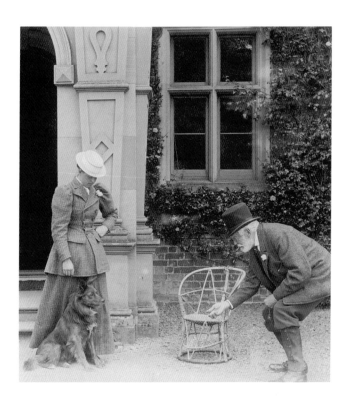

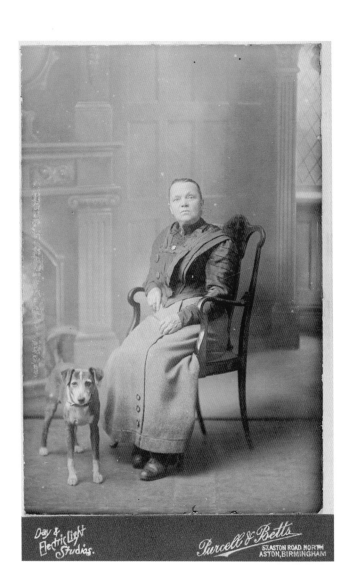

Day & Electric Light Studios.

Purcell & Betts
57, ASTON ROAD NORTH
ASTON, BIRMINGHAM

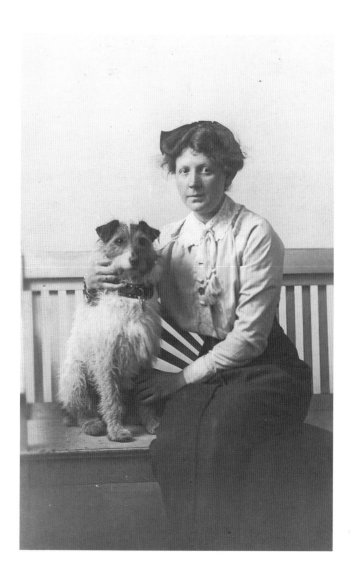

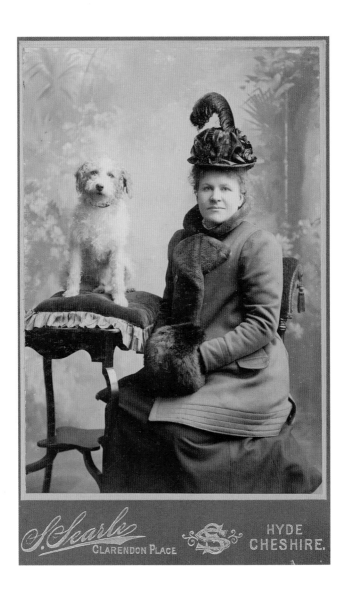

S. Searle
CLARENDON PLACE

HYDE
CHESHIRE.

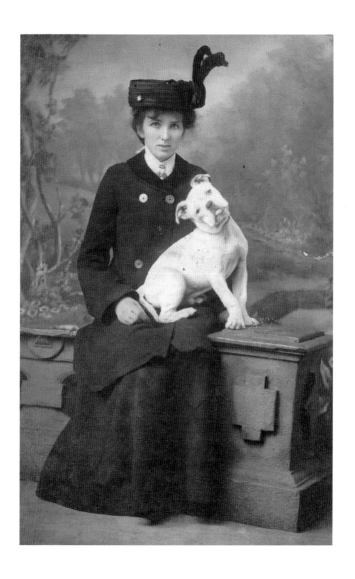

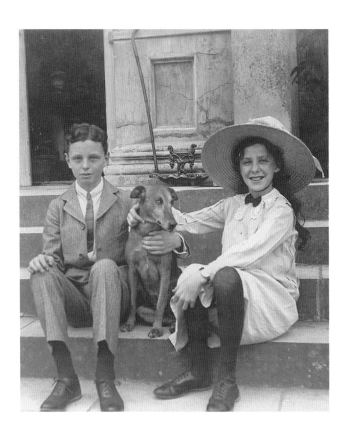

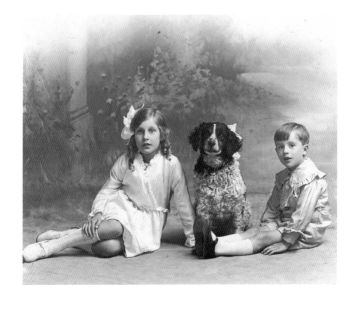

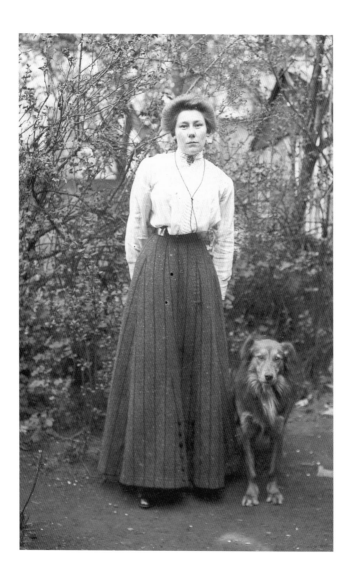

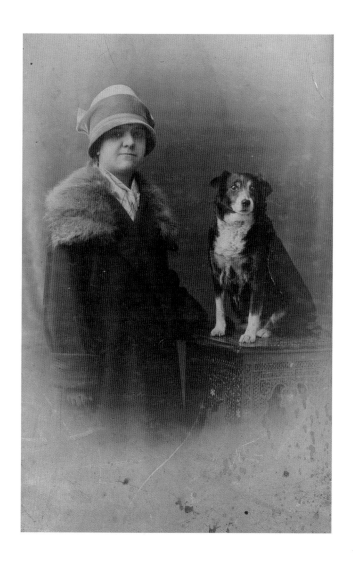

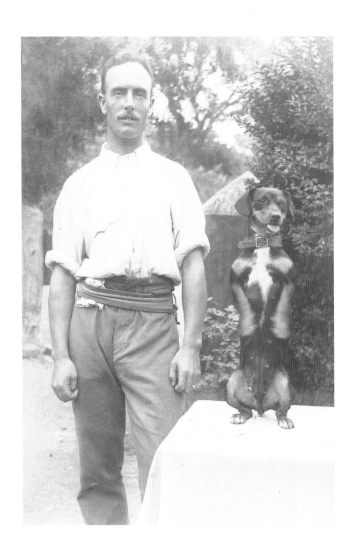

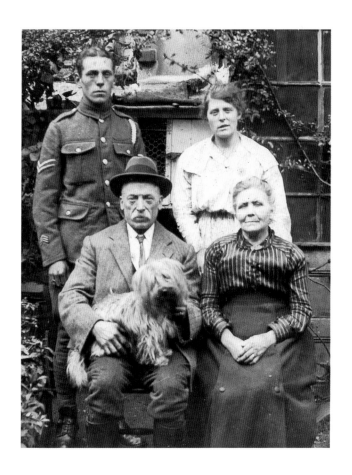

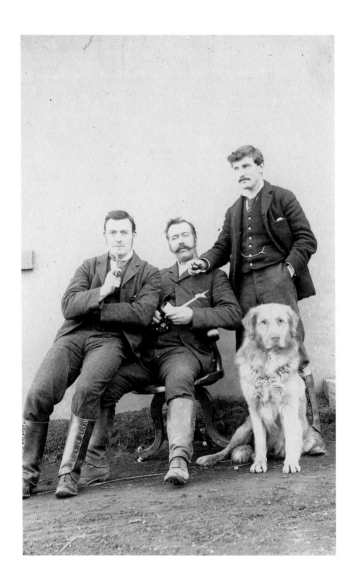

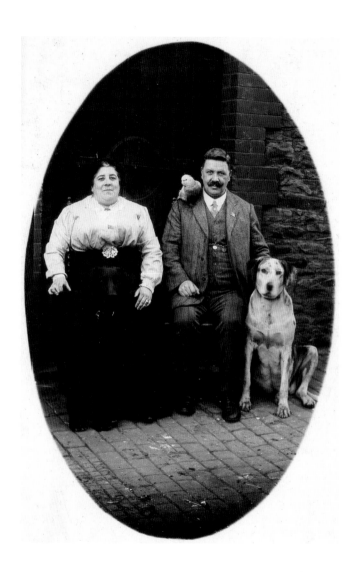

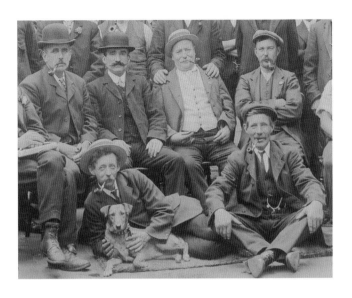

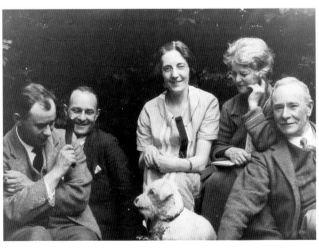

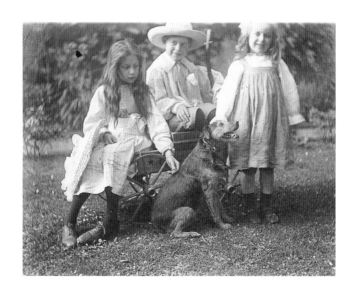

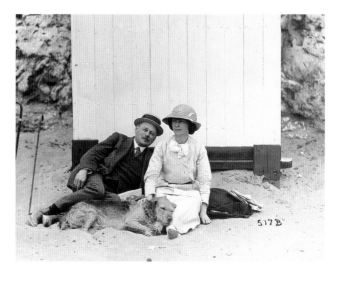

517 B

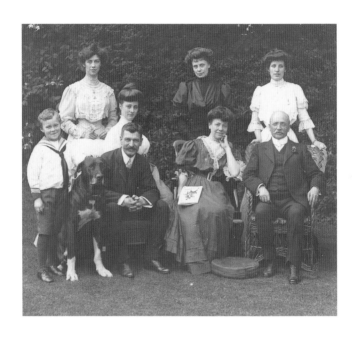

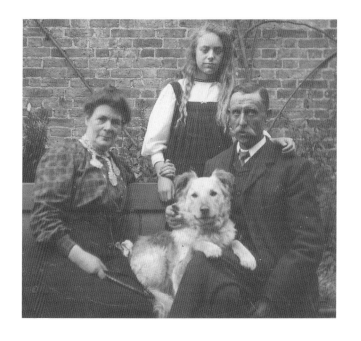

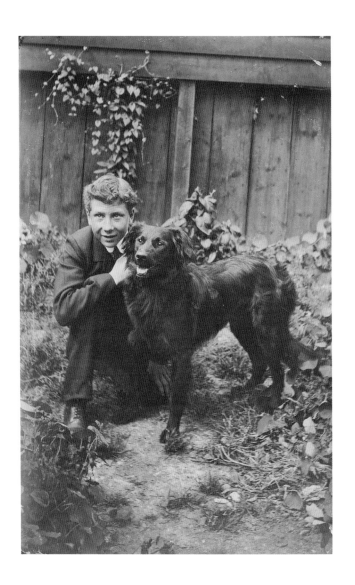

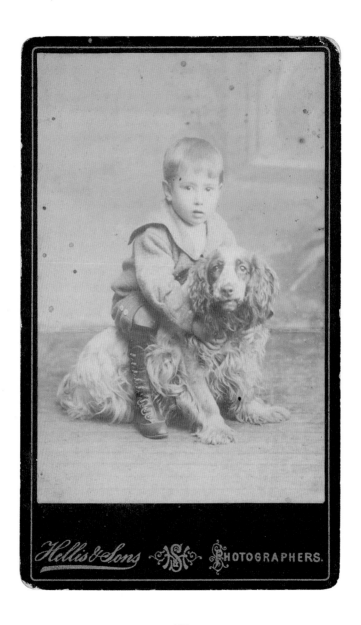

Hellis & Sons PHOTOGRAPHERS.

107

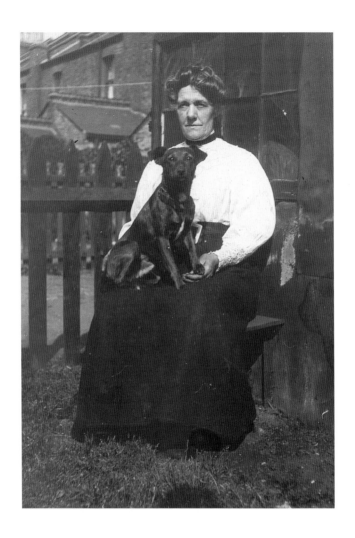

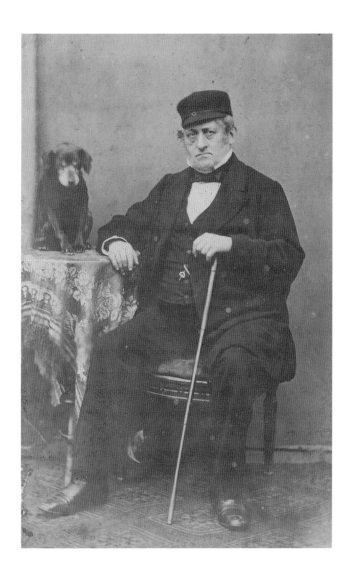

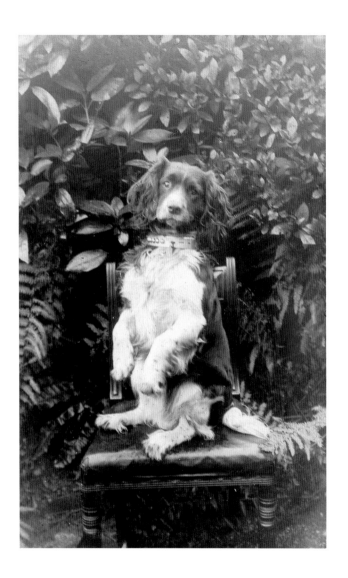

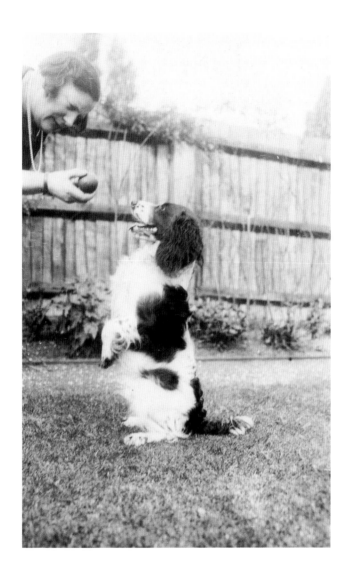

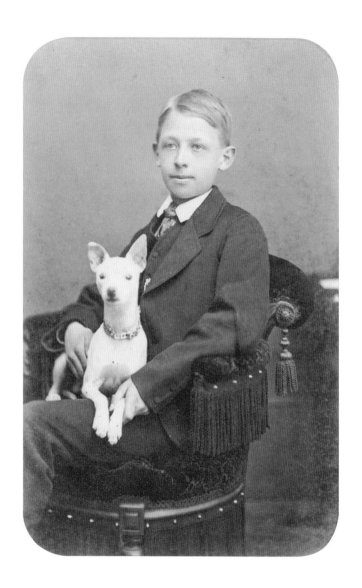

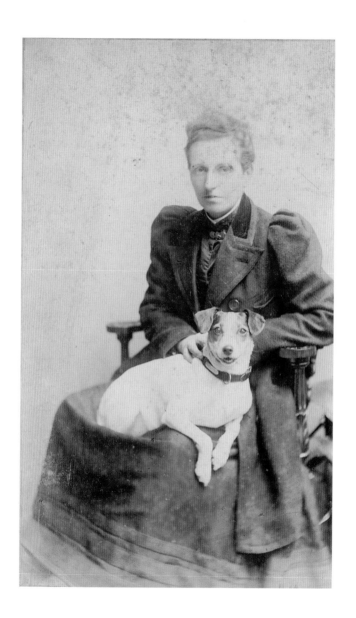

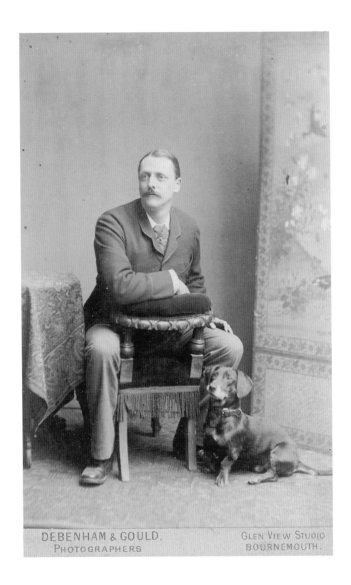

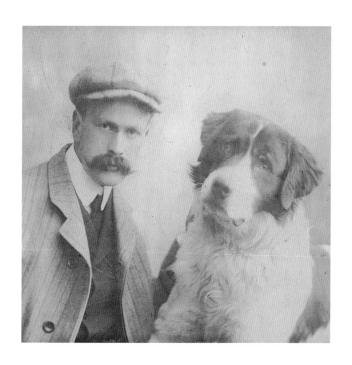

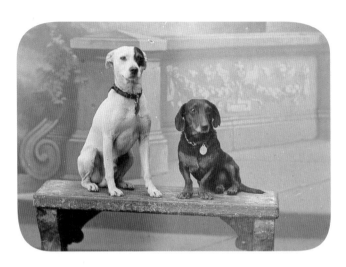

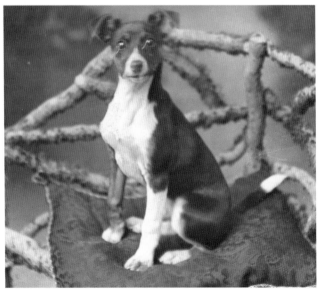

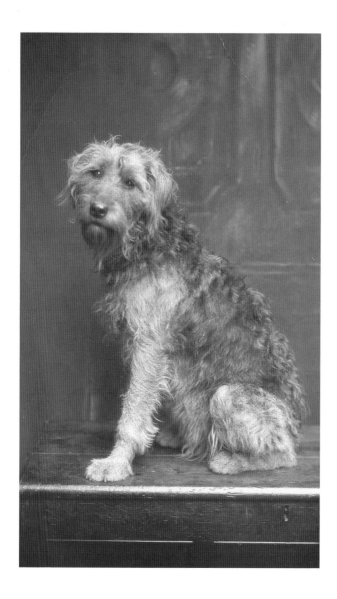

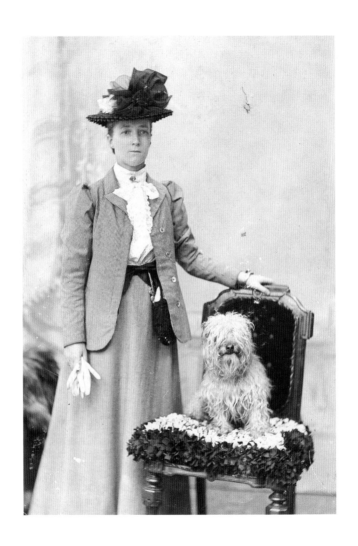

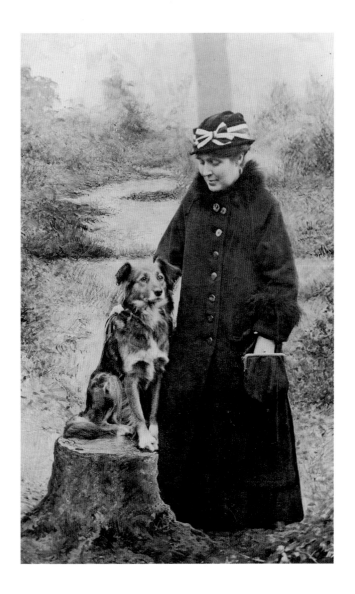

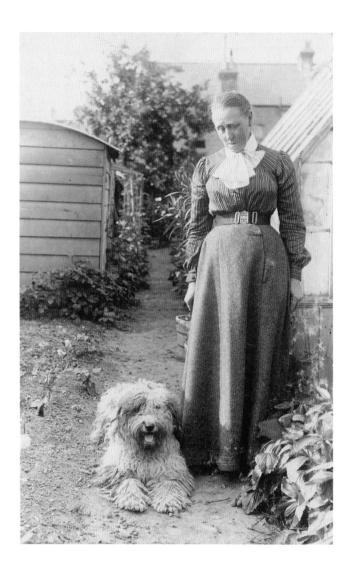

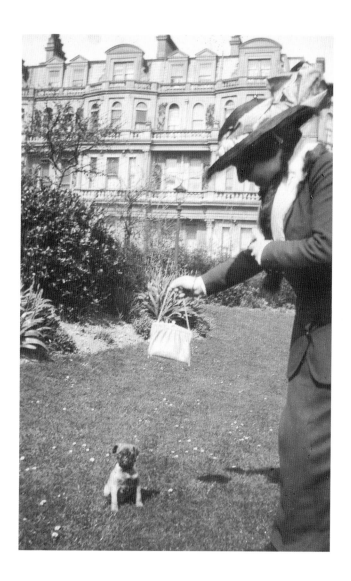

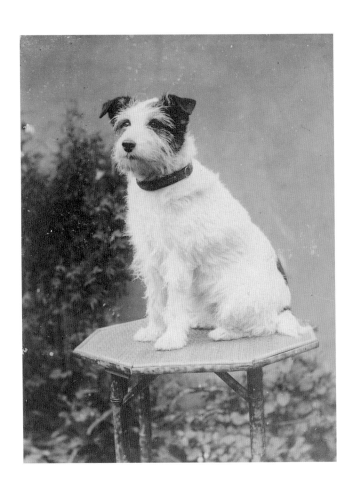

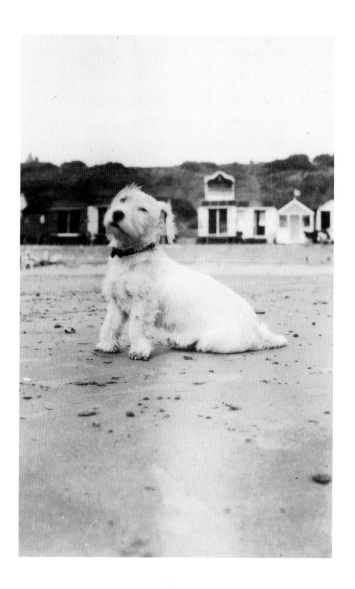

and one cat...

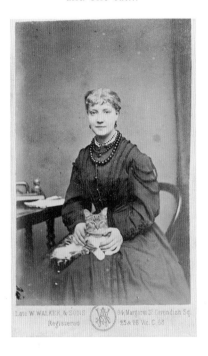

Thank you to Liz Calder and to everyone at Bloomsbury who've made my dream of this book come true; and to Tony and John for believing in it.